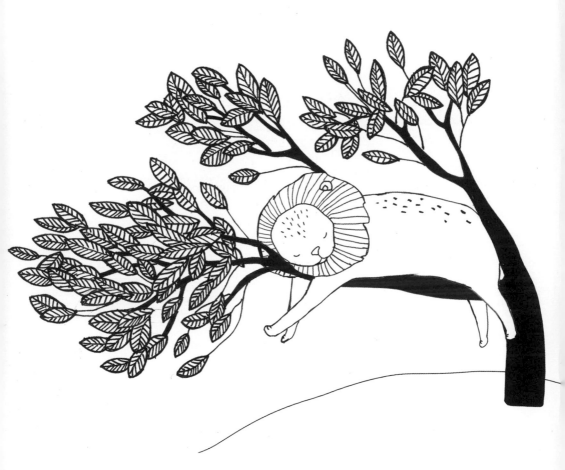

THE
illustrated
COMPENDIUM OF
amazing
ANIMAL FACTS

MAJA SÄFSTRÖM

TEN SPEED PRESS
BERKELEY

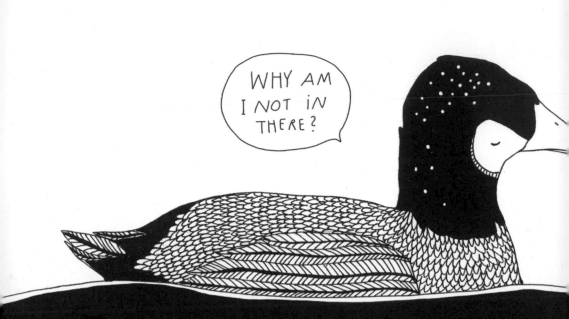

DEAR READER,

IN THIS BOOK i HAVE illUSTRATED
A BUNCH OF MY FAVORITE ANIMALS
AND SELECTED SOME AMAZING FACTS
ABOUT THEM TO SHARE WITH YOU.

THESE FACTS ARE MERELY GLIMPSES
OF ALL THE CRAZY, FANTASTIC,
AND iNTERESTING THINGS
THAT MAKE THESE ANIMALS SPECIAL.

i HOPE THAT YOU ENJOY THE BOOK,
LEARN SOMETHING NEW,
AND ARE REMINDED OF
THE FASCINATING BEAUTY
OF THE ANIMAL WORLD.

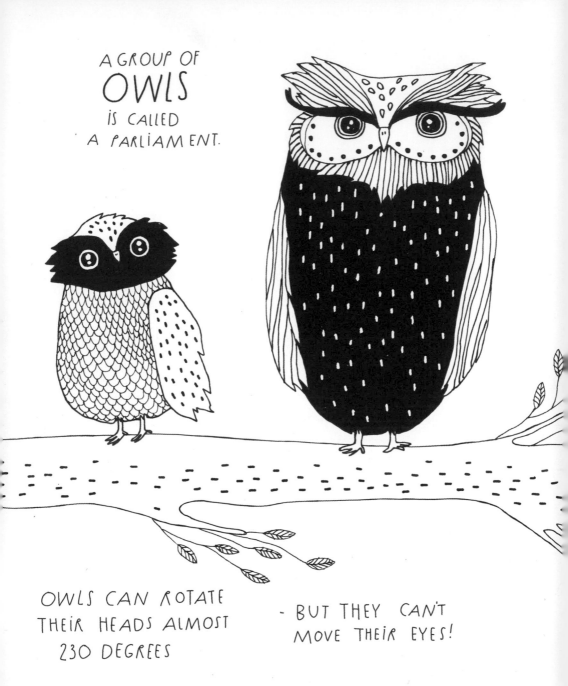

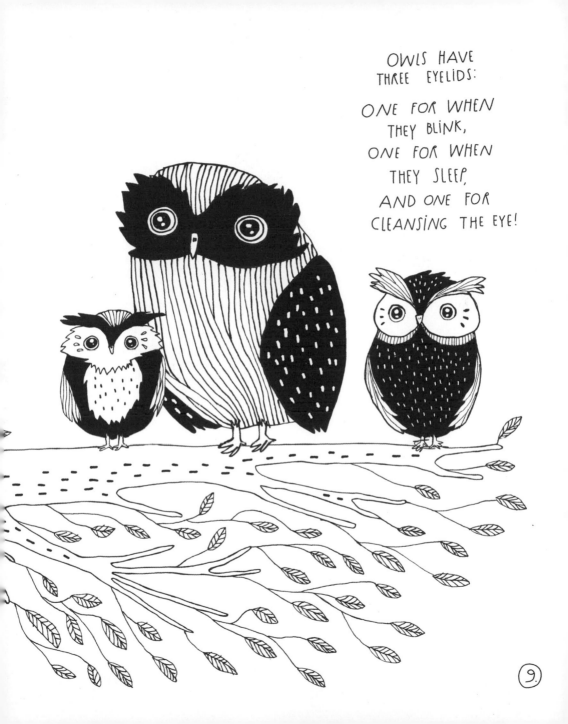

OWLS HAVE
THREE EYELIDS:

ONE FOR WHEN
THEY BLINK,
ONE FOR WHEN
THEY SLEEP,
AND ONE FOR
CLEANSING THE EYE!

⑨

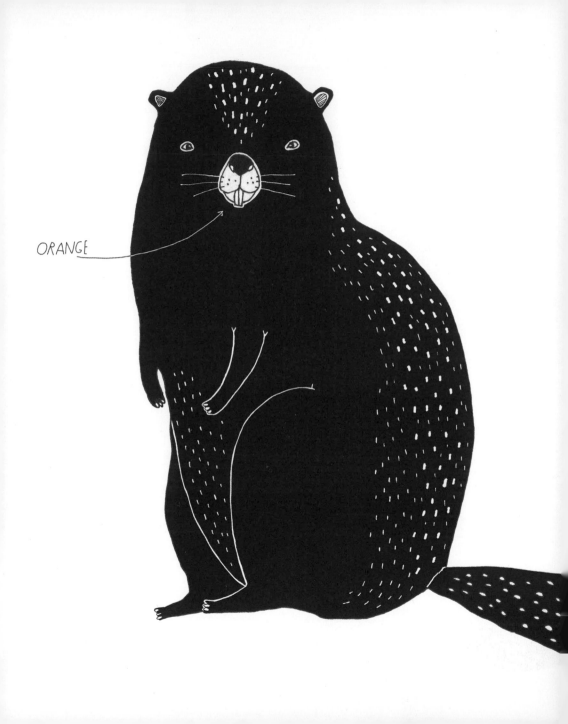

ORANGE

BEAVERS' TEETH ARE ORANGE AND THEY NEVER STOP GROWING!

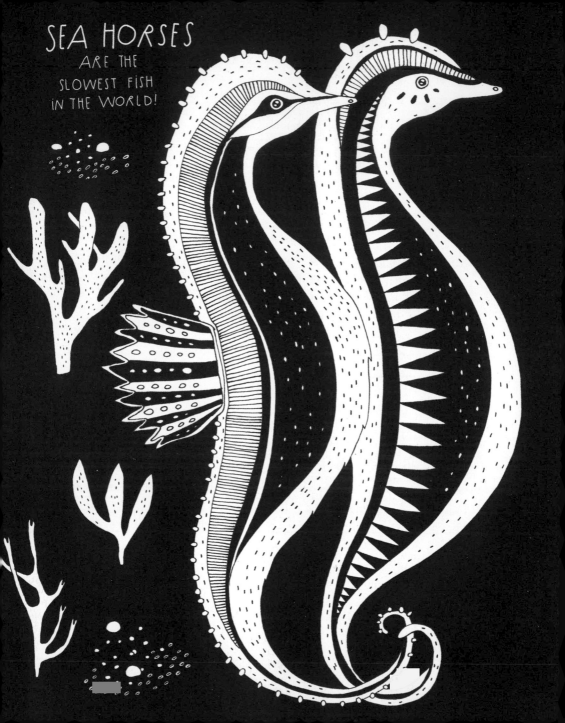

SEA HORSES
ARE THE
SLOWEST FISH
IN THE WORLD!

THEY HAVE NO TEETH
AND NO STOMACHS.

THEY LIVE IN PAIRS
AND TRAVEL HOLDING
EACH OTHER'S TAILS!

(13.)

THE SKIN OF THE
PANDA
IS BLACK
UNDER ITS BLACK FUR
AND PINK
UNDER ITS
WHITE FUR.

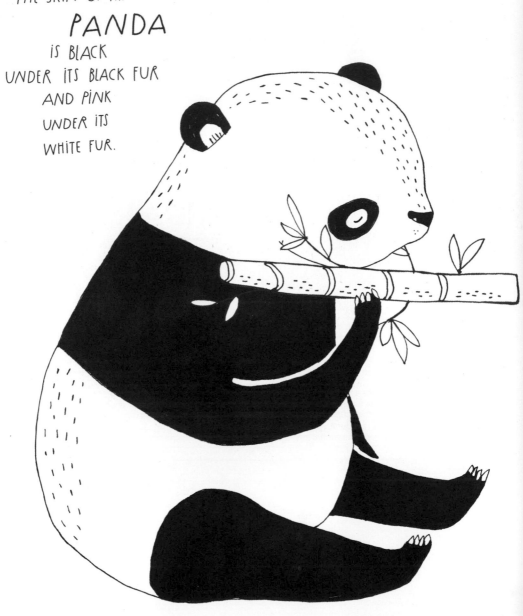

A PANDA'S DIET CONSISTS OF 99% BAMBOO, BUT THEIR STOMACHS ARE ACTUALLY DESIGNED TO EAT MEAT.

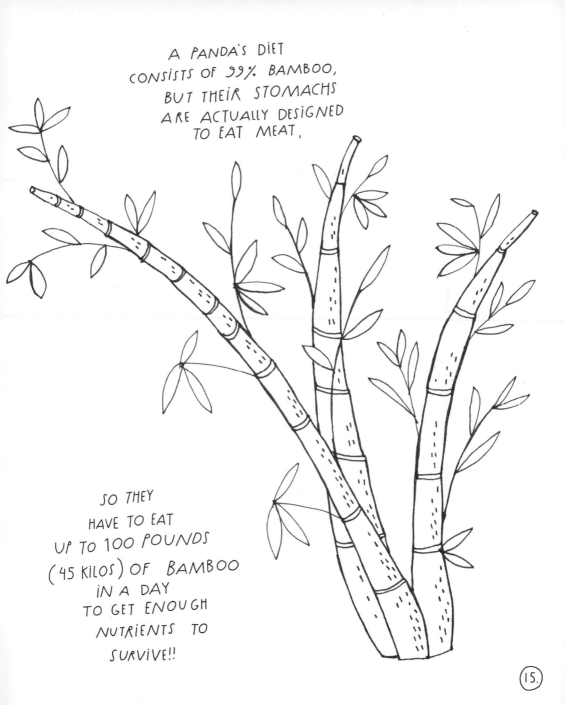

SO THEY HAVE TO EAT UP TO 100 POUNDS (45 KILOS) OF BAMBOO IN A DAY TO GET ENOUGH NUTRIENTS TO SURVIVE!!

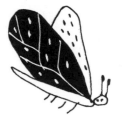

THE ORIGINAL
NAME FOR THE
BUTTERFLY
WAS FLUTTERBY!!

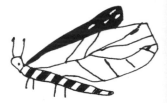

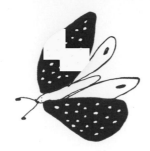

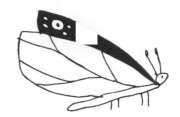

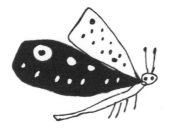

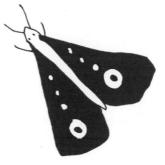

SOME BUTTERFLIES
NEVER EAT
ANYTHING AS ADULTS
BECAUSE THEY DON'T
HAVE MOUTHS...

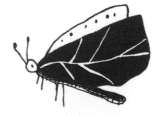

...THEY MUST LIVE ON
THE ENERGY THEY STORED
AS CATERPILLARS!

17.

KANGAROOS

CAN'T WALK BACKWARD.
(ACTUALLY THEY *NEVER* WALK,
THEY MOVE BY JUMPING FORWARD.)

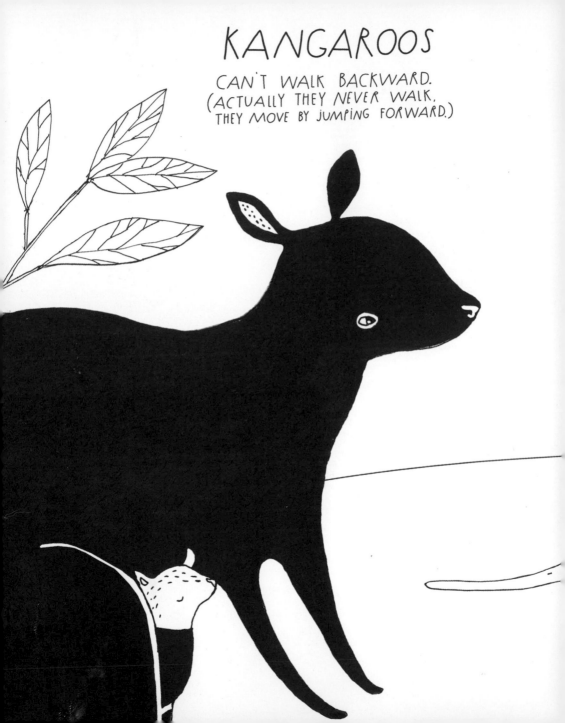

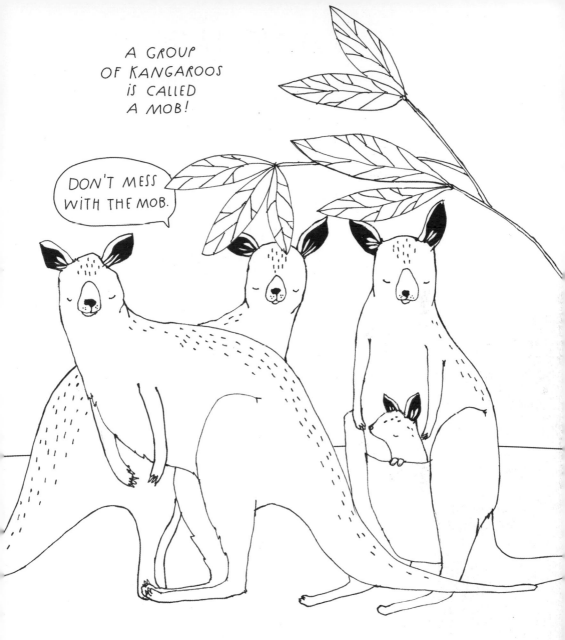

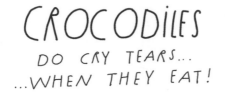

CROCODILES
DO CRY TEARS...
...WHEN THEY EAT!

RELAX BRO'
I'M ON A
STONE DIET!

BUT THEY DON'T CHEW
THEIR FOOD, INSTEAD THEY
SWALLOW STONES THAT
HELP GRIND IT
IN THEIR STOMACHS!

A CROCODILE CAN
SURVIVE WITHOUT FOOD
FOR THREE <u>YEARS</u> !!

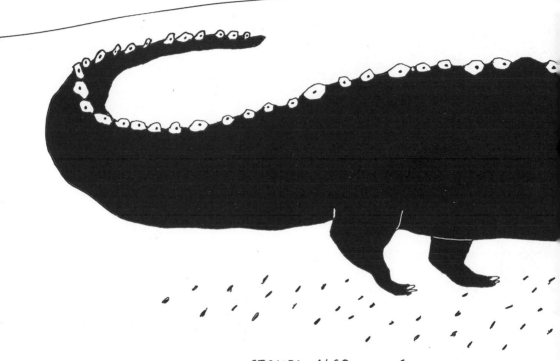

THE STONES ALSO
MAKES THEM FEEL
LESS HUNGRY, AND HELP
THEM DIVE DEEPER.

ARMADILLOS
ARE NEARLY BLIND AND DEAF BUT HAVE A GREAT SENSE OF SMELL.

THERE IS ONE TYPE OF
ARMADILLO THAT IS PINK.

IT IS CALLED
"THE PINK FAIRY ARMADILLO."

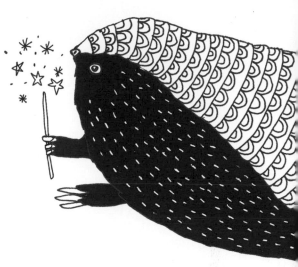

NINE-BANDED
ARMADILLOS
ALWAYS GIVE BIRTH
TO FOUR IDENTICAL
BABIES.

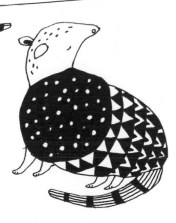

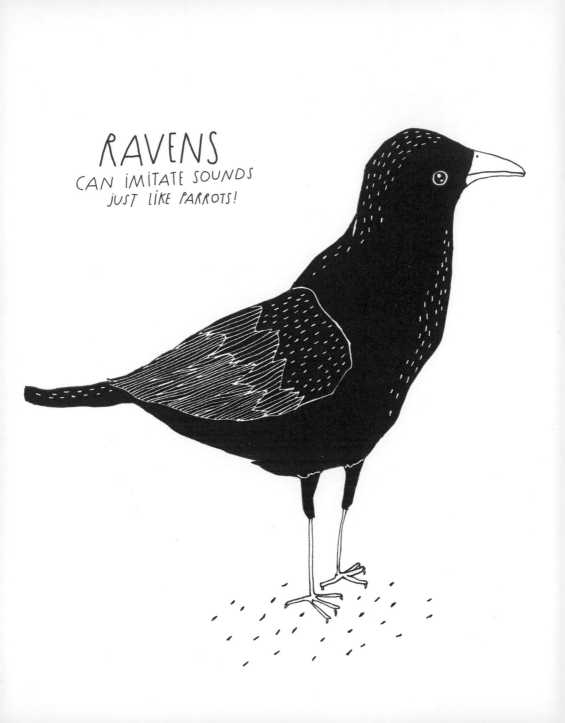

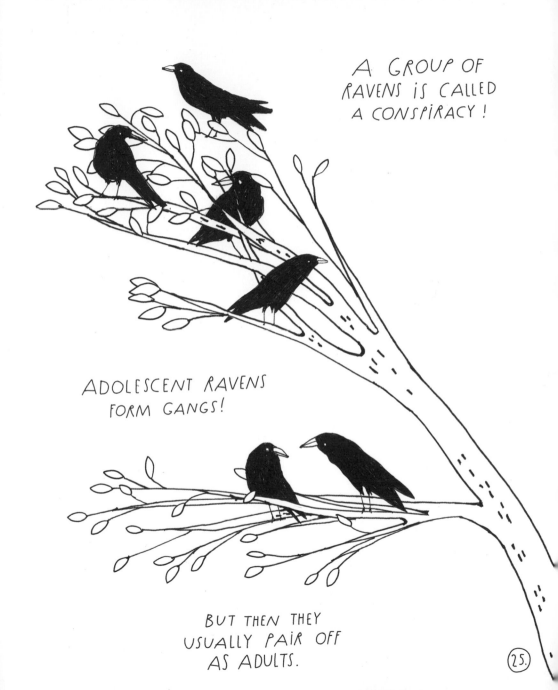

A GROUP OF RAVENS IS CALLED A CONSPIRACY!

ADOLESCENT RAVENS FORM GANGS!

BUT THEN THEY USUALLY PAIR OFF AS ADULTS.

MOSQUITOES

*NOT ONLY BITE YOU –
THEY ALSO PEE ON YOU!*

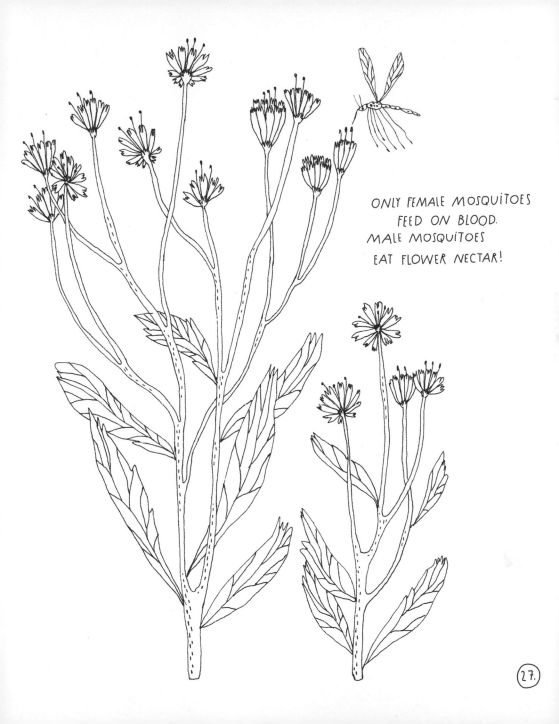

ONLY FEMALE MOSQUITOES
FEED ON BLOOD.
MALE MOSQUITOES
EAT FLOWER NECTAR!

27.

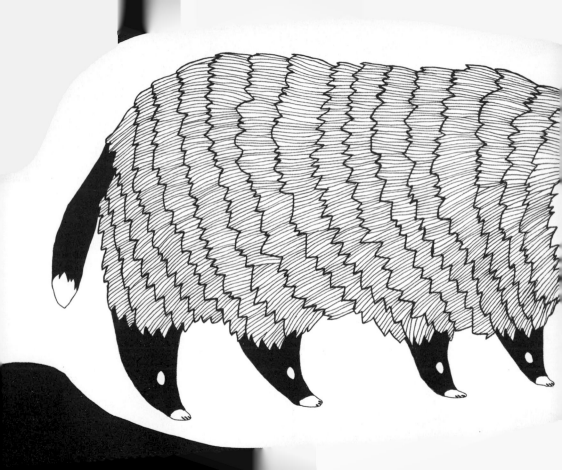

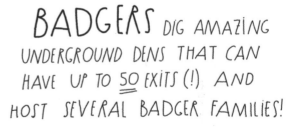

BADGERS DIG AMAZING UNDERGROUND DENS THAT CAN HAVE UP TO 50 EXITS (!) AND HOST SEVERAL BADGER FAMILIES!

SEA OTTERS

HOLD HANDS WHEN THEY SLEEP
iN THE WATER SO THEY DON'T
FLOAT AWAY FROM EACH OTHER!

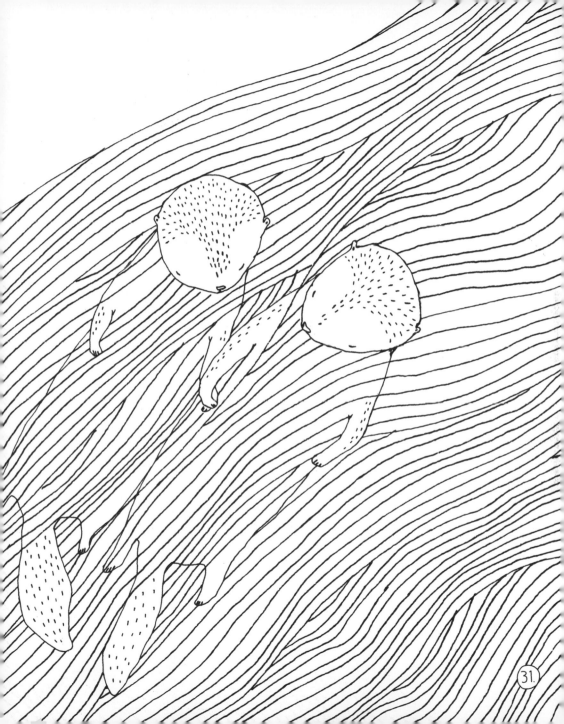

31.

KIWIS CAN'T FLY.
(THEY DO HAVE WINGS
BUT THEY ARE VERY TINY.)

iF A SNAiL DOESN'T LiKE THE WEATHER, iT CAN GO iNTO iTS SHELL AND HiBERNATE UNTiL iT GETS BETTER. FOR UP TO THREE YEARS!!!

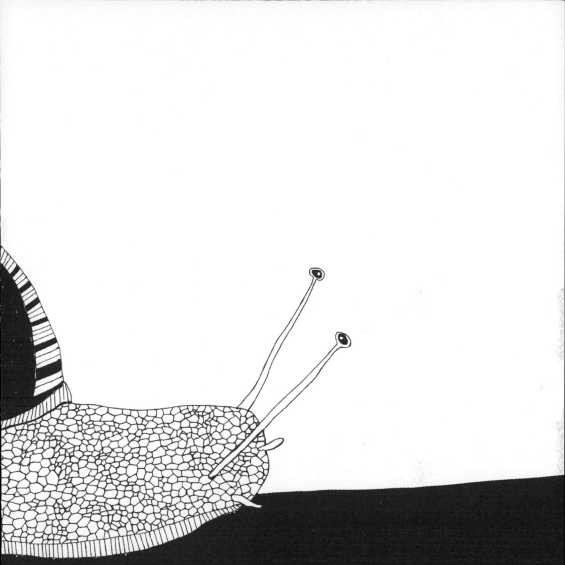

AN
OCTOPUS
HAS MORE
BRAIN CELLS
THAN A
HUMAN.

THEY CAN
SMELL AND
TASTE WITH
THEIR ARMS.

AND
THEY USE
TOOLS!

THEY HAVE
THREE HEARTS!

THEY HAVE MOST
OF THEIR NEURONS
IN THEIR ARMS
=
THEIR ARMS HAVE
MINDS OF THEIR OWN!!

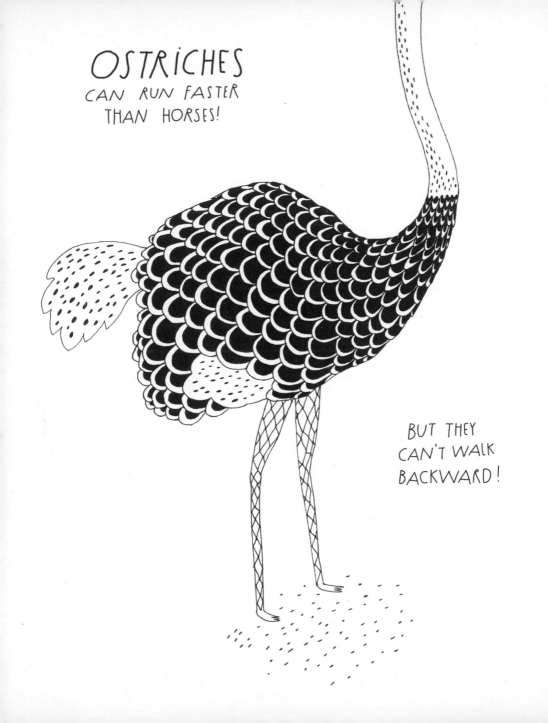

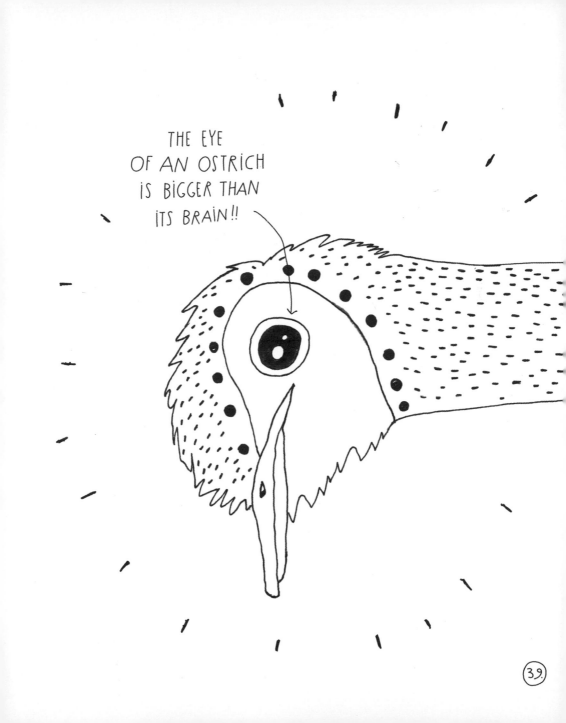

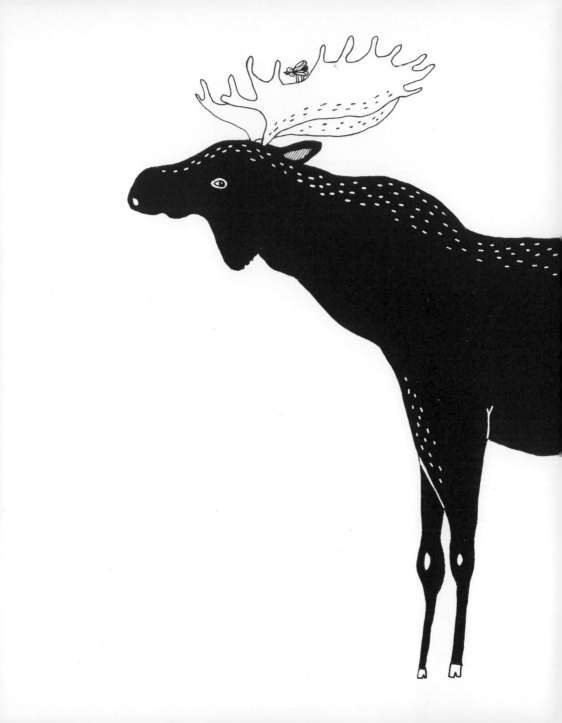

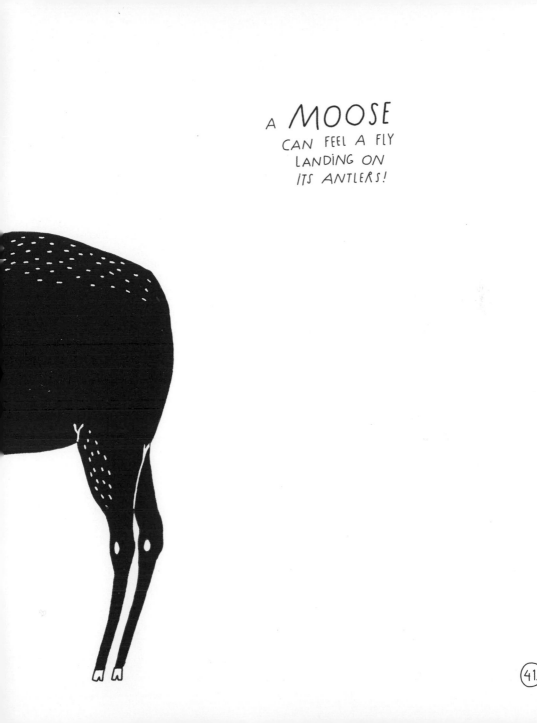

A MOOSE
CAN FEEL A FLY
LANDING ON
ITS ANTLERS!

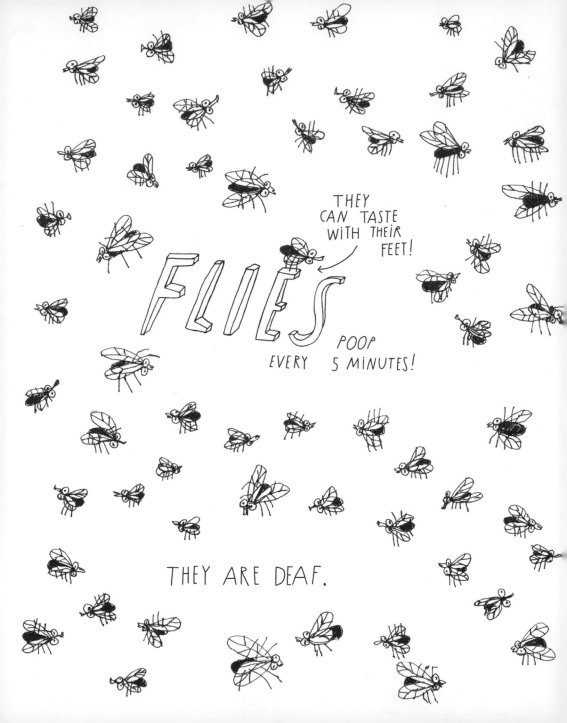

THEY CAN TASTE WITH THEIR FEET!

FLIES

POOP EVERY 5 MINUTES!

THEY ARE DEAF.

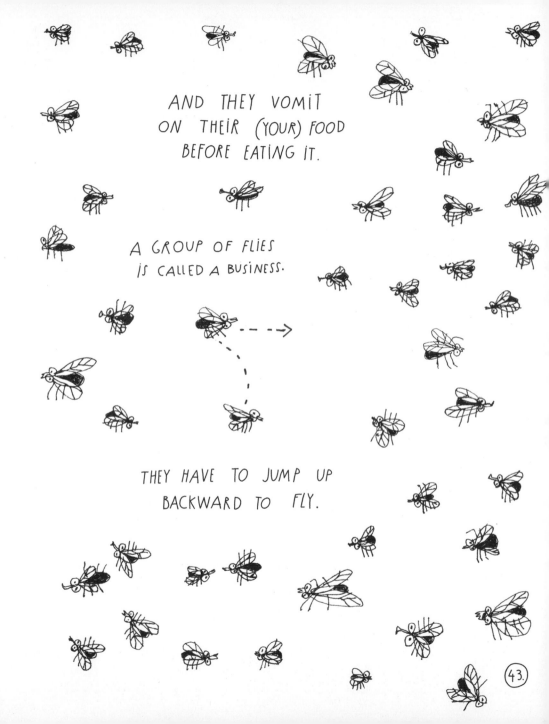

AND THEY VOMIT
ON THEIR (YOUR) FOOD
BEFORE EATING IT.

A GROUP OF FLIES
IS CALLED A BUSINESS.

THEY HAVE TO JUMP UP
BACKWARD TO FLY.

43.

TURTLES AND TORTOISES

CAN LIVE TO BE
MORE THAN
150 YEARS OLD.

TORTOISE
(LIVES ON LAND)

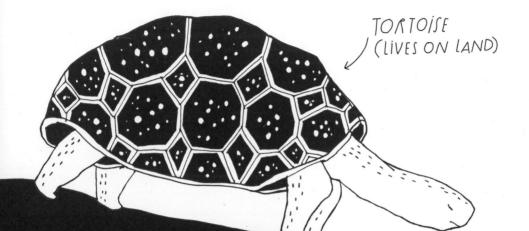

TURTLE SHELLS
ARE MADE OF 60
DIFFERENT BONES
ALL CONNECTED
TOGETHER.

AND THEY
CAN FEEL THROUGH
THEIR SHELLS!

THE CHINESE LEATHER TURTLE
PEES THROUGH ITS MOUTH!

SEA TURTLE

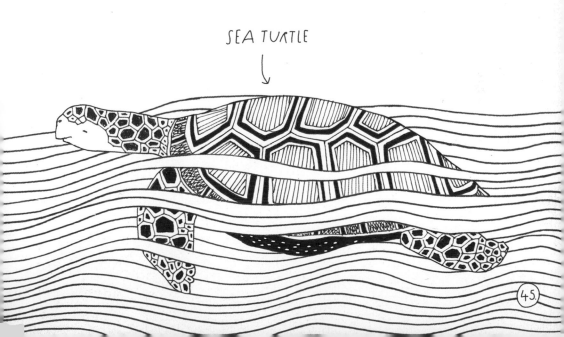

45.

HUMMINGBIRDS
FLAP THEIR WINGS UP TO 200 TIMES A SECOND!!!

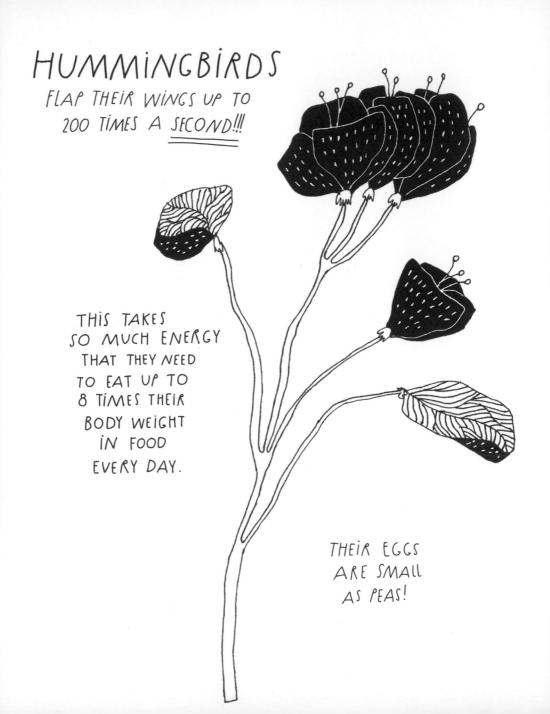

THIS TAKES SO MUCH ENERGY THAT THEY NEED TO EAT UP TO 8 TIMES THEIR BODY WEIGHT IN FOOD EVERY DAY.

THEIR EGGS ARE SMALL AS PEAS!

THEY ARE THE ONLY BIRDS
.THAT CAN FLY BACKWARD!

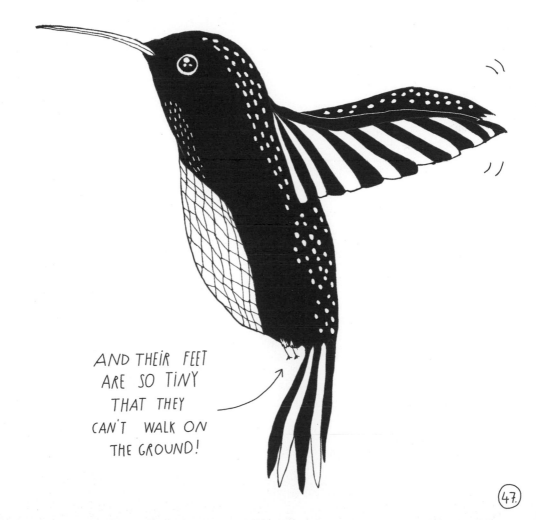

AND THEIR FEET
ARE SO TINY
THAT THEY
CAN'T WALK ON
THE GROUND!

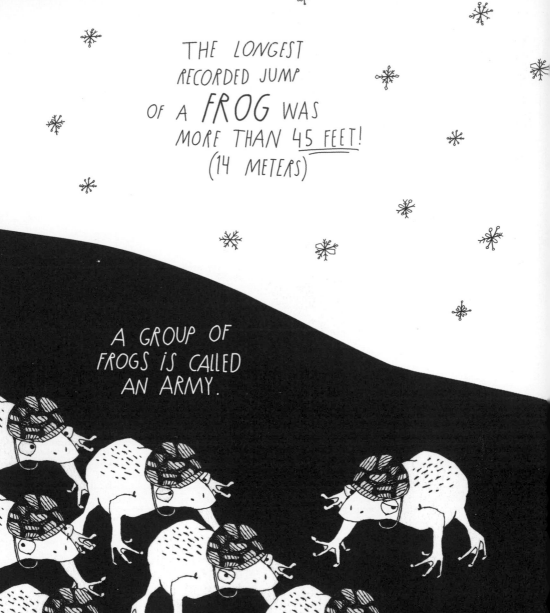

THE LONGEST RECORDED JUMP OF A **FROG** WAS MORE THAN <u>45 FEET</u>! (14 METERS)

A GROUP OF FROGS IS CALLED AN ARMY.

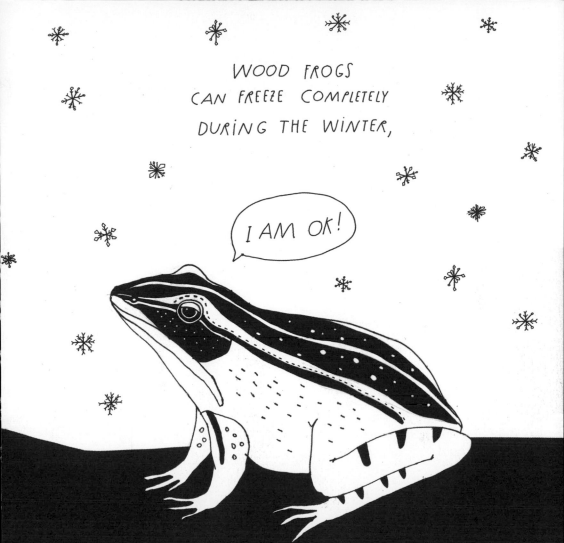

MALE EMPEROR PENGUINS
GUARD THE EGGS
FOR TWO MONTHS
WITHOUT EATING
WHILE THE FEMALES
GO TO GET FOOD.

PENGUINS
CAN'T FLY.

BUT THEY CAN JUMP
ALMOST 6.5 FEET (2 METERS)
OUT OF THE WATER!

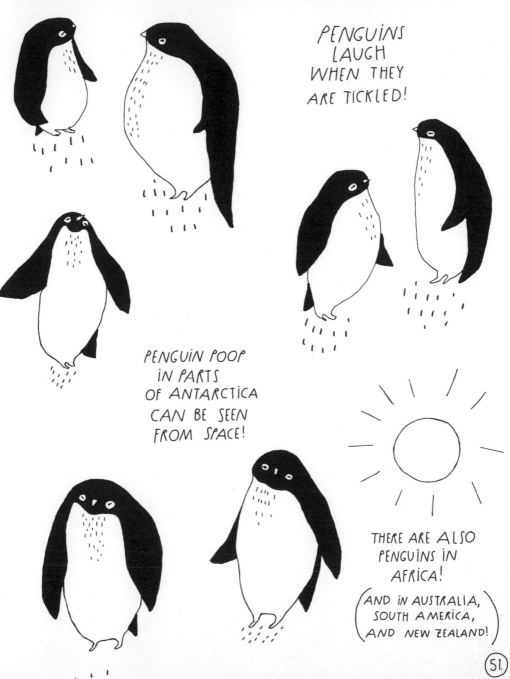

PENGUINS
LAUGH
WHEN THEY
ARE TICKLED!

PENGUIN POOP
IN PARTS
OF ANTARCTICA
CAN BE SEEN
FROM SPACE!

THERE ARE ALSO
PENGUINS IN
AFRICA!

(AND IN AUSTRALIA,
SOUTH AMERICA,
AND NEW ZEALAND!)

51.

THE HEART OF A
MOUSE
BEATS UP TO
750 TIMES PER MINUTE.

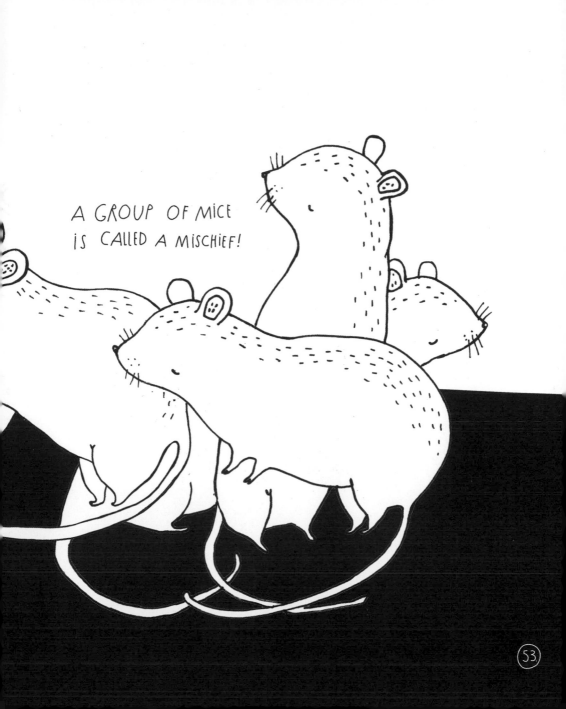

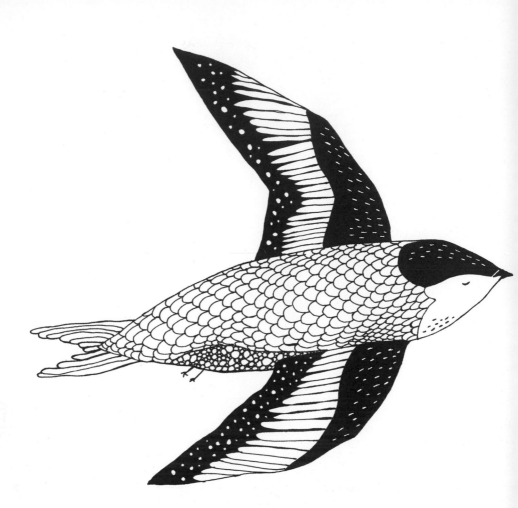

SWIFTS

SPEND MOST OF THEIR
LIVES IN THE AIR.

THEY CAN FLY NONSTOP
FOR OVER SIX MONTHS!!

THIS INCLUDES
EATING, RESTING,
AND MATING
IN THE AIR!

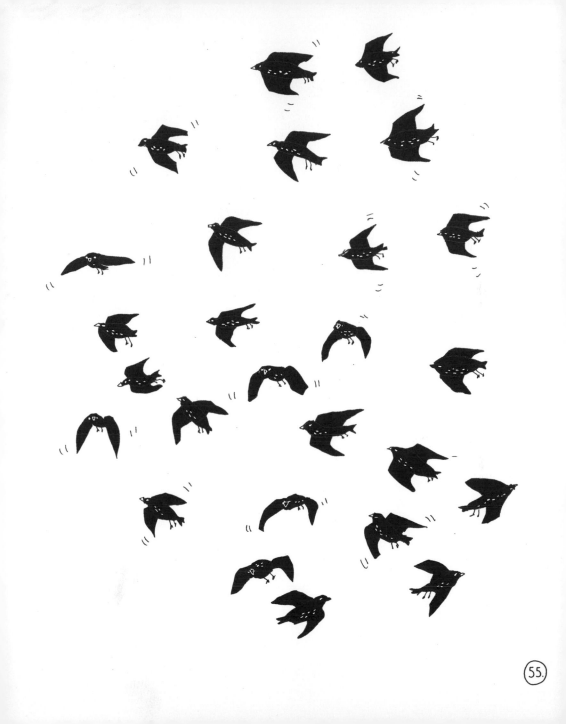

A TARANTULA
CAN SURVIVE FOR MORE THAN
2 YEARS WITHOUT FOOD!

THEY HAVE
RETRACTABLE CLAWS
ON THEIR "FEET" —
JUST LIKE CATS!

IF A TARANTULA
LOSES A LEG, IT WILL JUST
GROW A NEW ONE!!

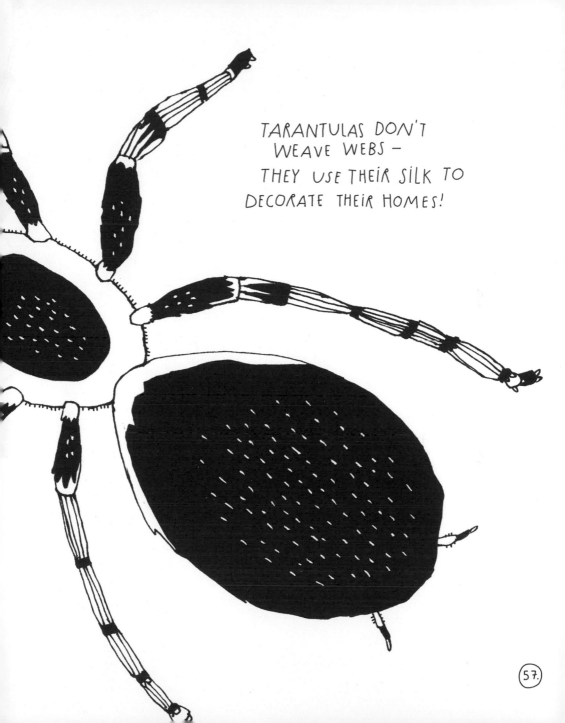

TARANTULAS DON'T
WEAVE WEBS —
THEY USE THEIR SILK TO
DECORATE THEIR HOMES!

ZEBRAS

ARE ACTUALLY BLACK
WITH WHITE STRIPES –
NOT WHITE
WITH BLACK STRIPES!

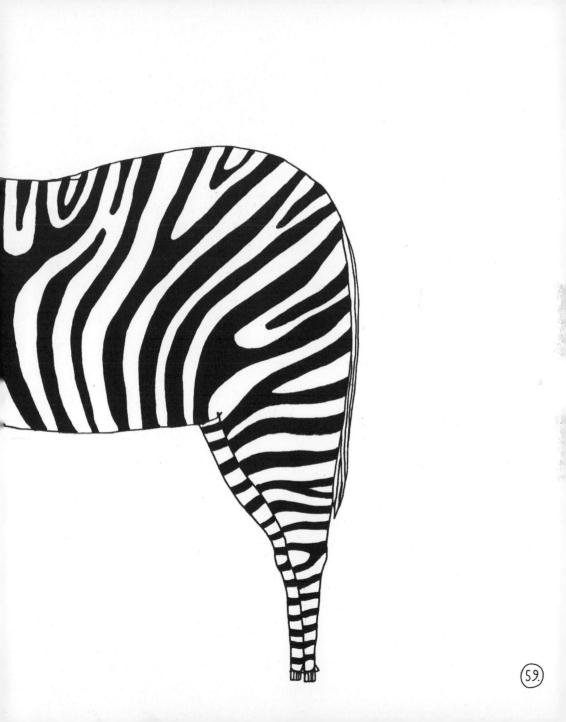

ALL **CLOWNFISH** ARE BORN MALE.

WHEN THE
FEMALE CLOWNFISH
IN A GROUP DIES,
THE MOST DOMINANT MALE
WILL TURN INTO A FEMALE
TO TAKE HER PLACE!

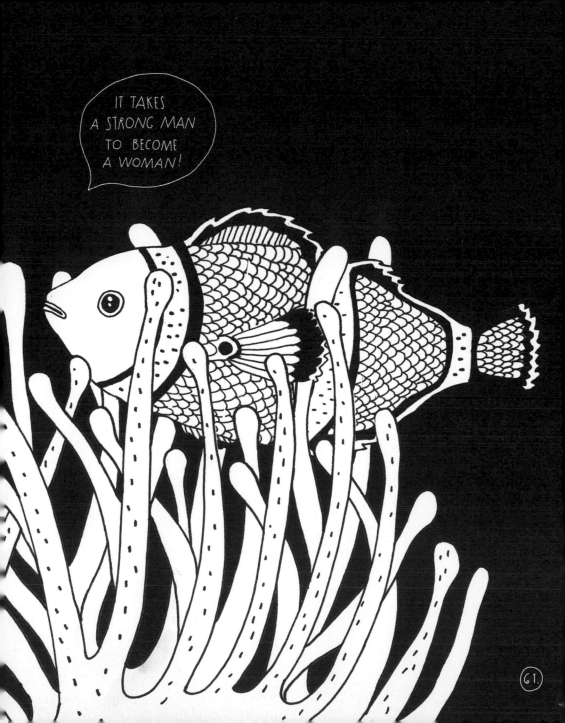

ANTS

HAVE NO LUNGS!

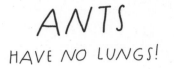

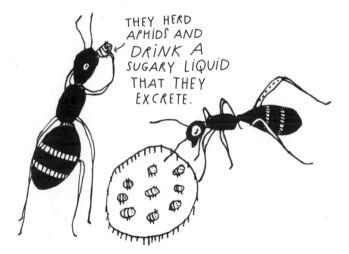

THEY HERD
APHIDS AND
DRINK A
SUGARY LIQUID
THAT THEY
EXCRETE.

ANTS ARE THE
ONLY ANIMALS
EXCEPT HUMANS
THAT FARM OTHER ANIMALS!

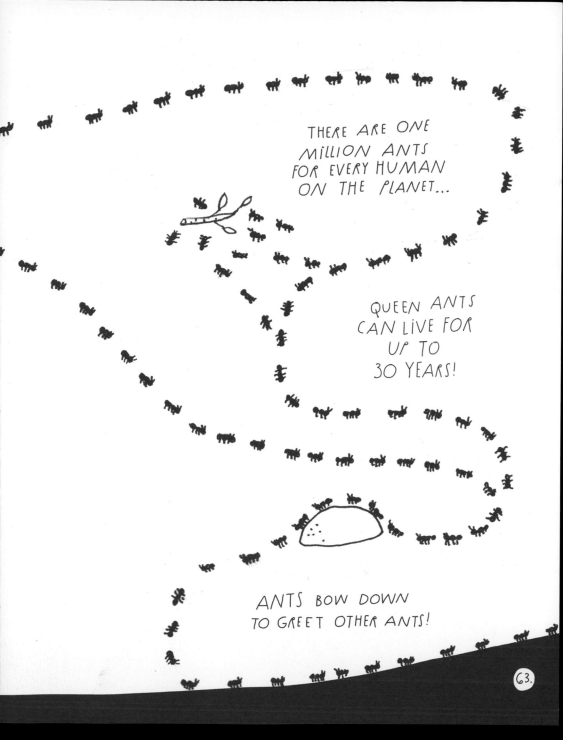

THERE ARE ONE
MILLION ANTS
FOR EVERY HUMAN
ON THE PLANET...

QUEEN ANTS
CAN LIVE FOR
UP TO
30 YEARS!

ANTS BOW DOWN
TO GREET OTHER ANTS!

GIANT ANTEATERS
EAT ABOUT 30,000
ANTS AND TERMITES EVERY DAY!

THEY HAVE
NO TEETH!

BUT THEIR TONGUES
ARE VERY STICKY

AND UP TO 24 INCHES
(60 CM) LONG!

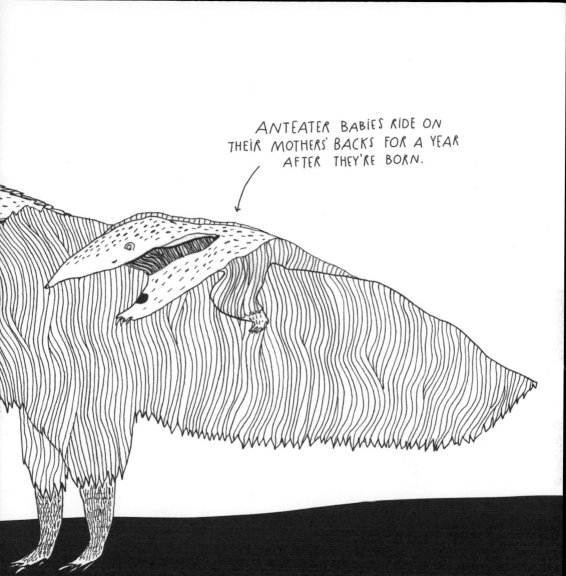

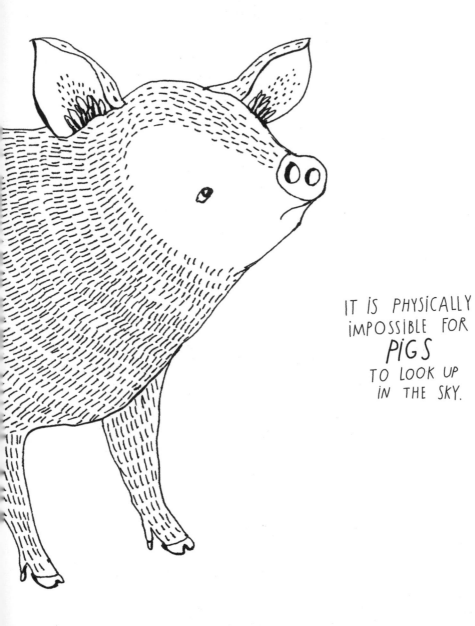

IT IS PHYSICALLY
IMPOSSIBLE FOR
PIGS
TO LOOK UP
IN THE SKY.

BLUE WHALES

SLEEP WITH
HALF THEIR BRAINS
SHUT DOWN
AT A TIME

OTHERWISE
THEY WOULD FORGET
TO COME UP TO
THE SURFACE TO BREATHE
AND DROWN!!

BLUE WHALES
EAT 12,000 POUNDS
(5,400 KILOS)
OF KRILL
EVERY DAY!

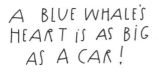

A BLUE WHALE'S
HEART IS AS BIG
AS A CAR!

THEY HAVE
BELLY BUTTONS!

69.

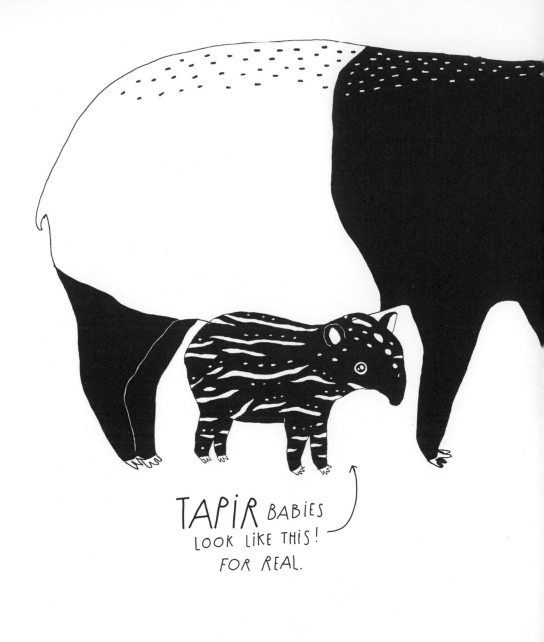

TAPIR BABIES LOOK LIKE THIS! FOR REAL.

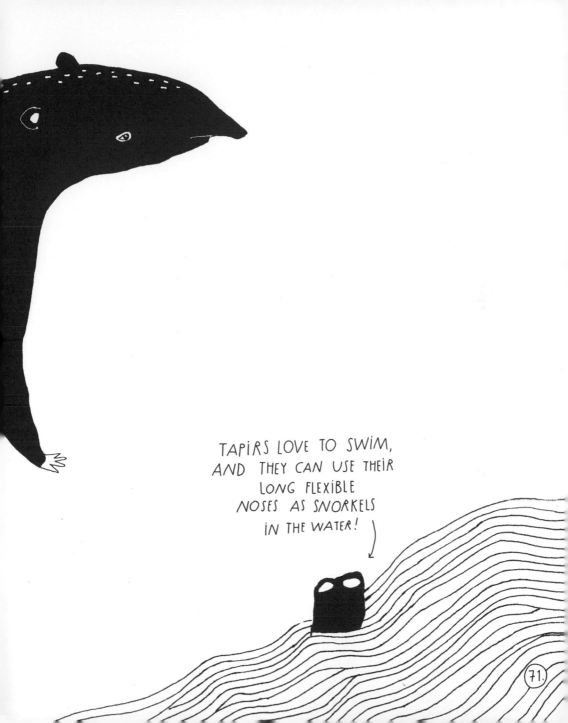

TAPIRS LOVE TO SWIM, AND THEY CAN USE THEIR LONG FLEXIBLE NOSES AS SNORKELS IN THE WATER!

GIRAFFES
HAVE VERY
LONG NECKS
TO REACH BRANCHES
HIGH IN THE AIR.

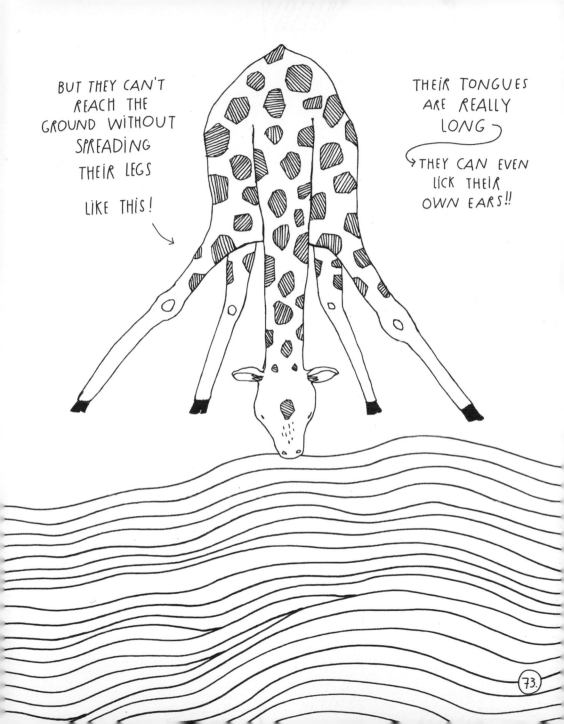

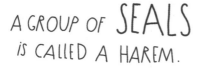

A GROUP OF **SEALS** IS CALLED A HAREM.

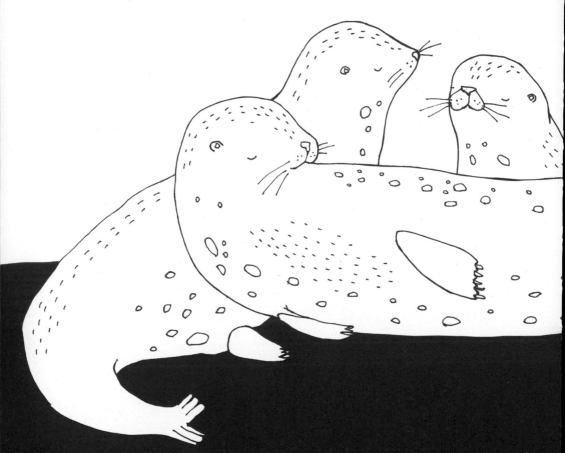

75.

CHAMELEONS

CAN MOVE THEIR EYES
SEPARATELY - AND LOOK
IN TWO DIRECTIONS AT
THE SAME TIME!

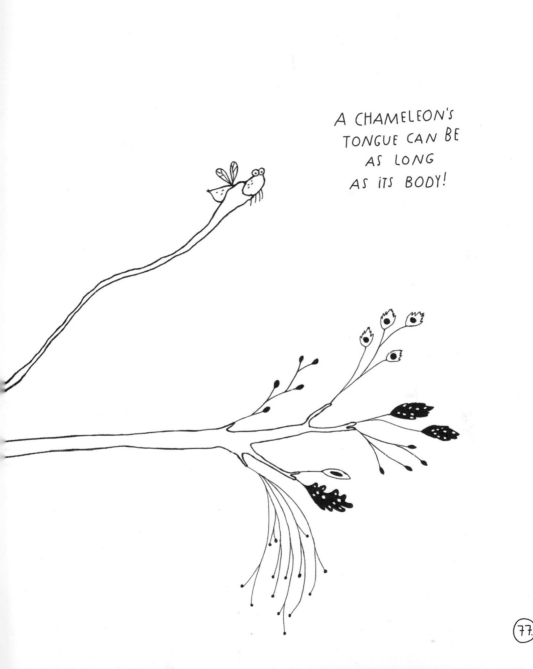

A CHAMELEON'S
TONGUE CAN BE
AS LONG
AS ITS BODY!

A GROUP OF
LIONS
IS CALLED A PRIDE!

FEMALE LIONS
ARE IN CHARGE
OF THE HUNTING.

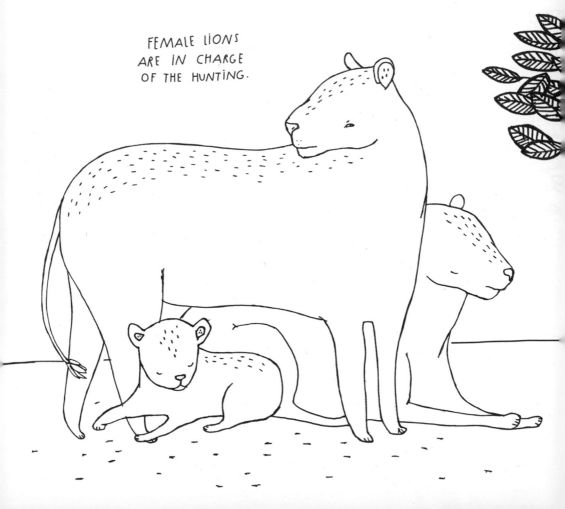

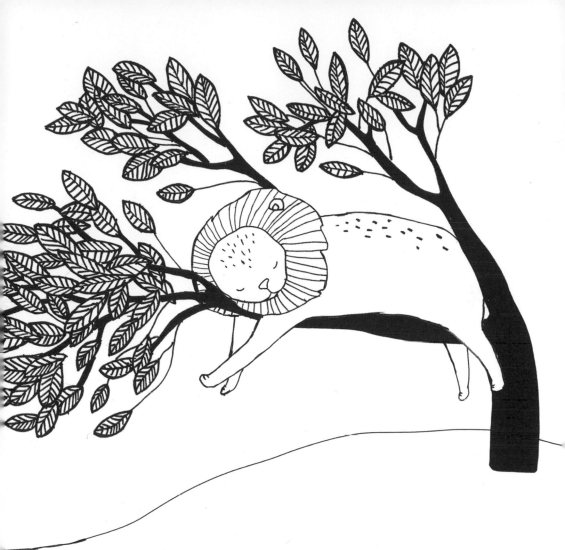

AND MALE LIONS
SLEEP UP TO
20 HOURS A DAY...

GOATS
HAVE DIFFERENT
ACCENTS DEPENDING
ON WHERE
THEY ARE FROM!

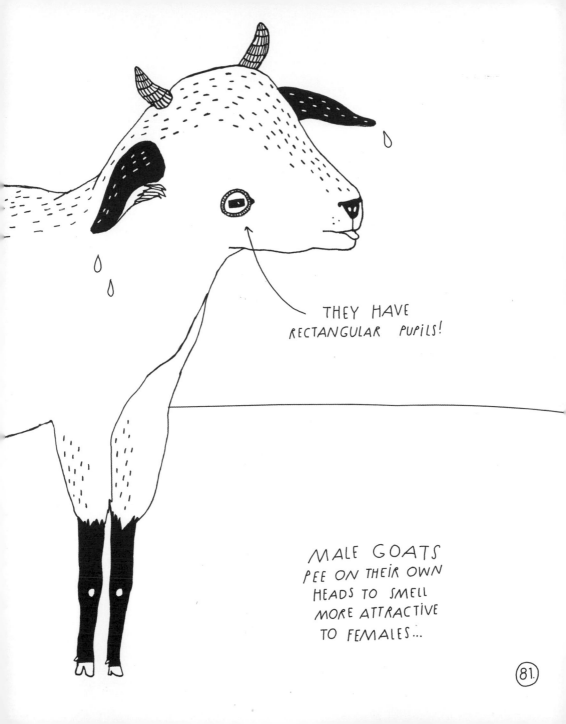

THEY HAVE
RECTANGULAR PUPILS!

MALE GOATS
PEE ON THEIR OWN
HEADS TO SMELL
MORE ATTRACTIVE
TO FEMALES...

81.

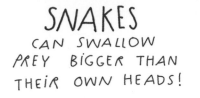

SNAKES
CAN SWALLOW PREY BIGGER THAN THEIR OWN HEADS!

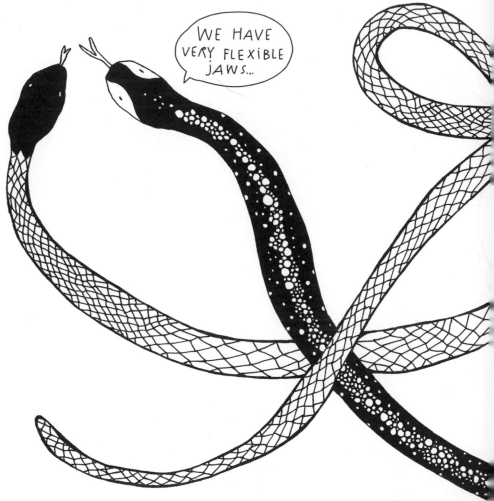

MOST SNAKES
LAY EGGS,
BUT SOME SPECIES
GIVE BIRTH
TO LIVE YOUNG—

UP TO 60 BABIES
AT A TIME!

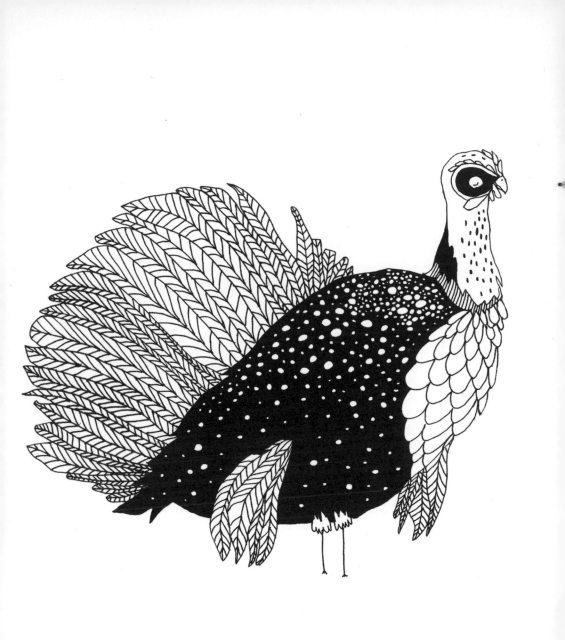

THE HEADS OF

WILD TURKEYS

CHANGE COLOR BETWEN
RED, WHITE, AND BLUE
DEPENDING ON THEIR MOOD.

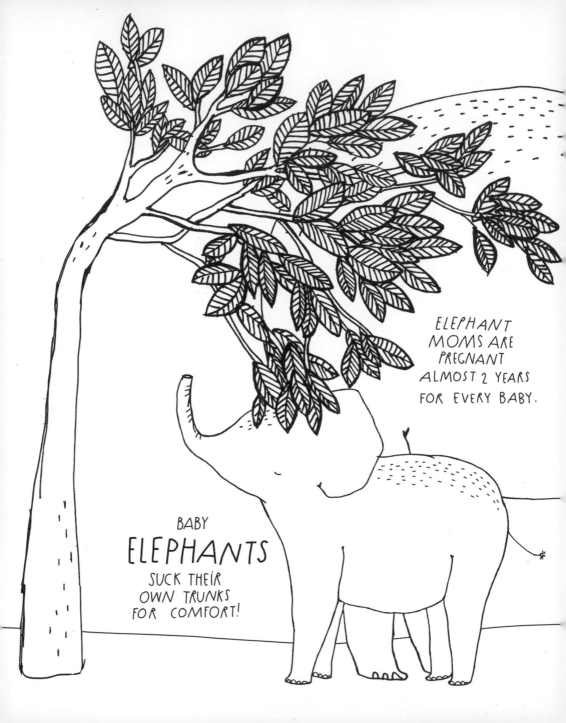

ELEPHANT
MOMS ARE
PREGNANT
ALMOST 2 YEARS
FOR EVERY BABY.

BABY
ELEPHANTS
SUCK THEIR
OWN TRUNKS
FOR COMFORT!

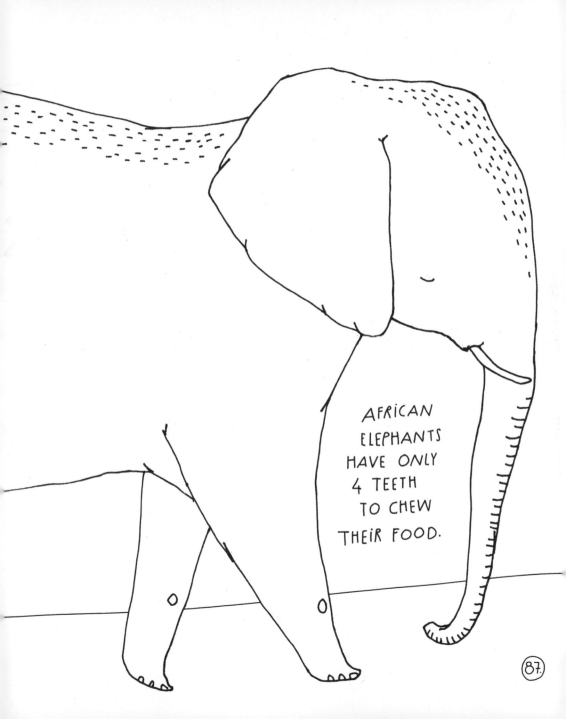

AFRICAN
ELEPHANTS
HAVE ONLY
4 TEETH
TO CHEW
THEIR FOOD.

87.

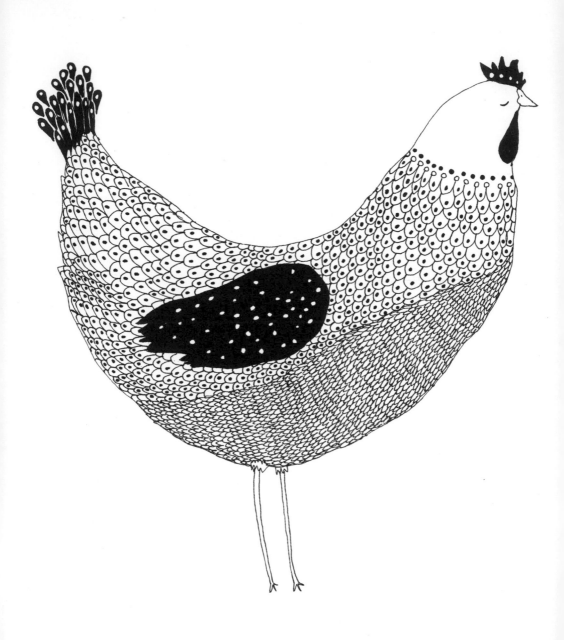

THE LONGEST RECORDED
FLIGHT OF A CHICKEN
IS 13 SECONDS!

BEES

NEVER SLEEP.

BEES NEED TO VISIT MORE THAN **4 MILLION** FLOWERS TO MAKE 2 POUNDS (1 KILO) OF HONEY.

HONEY CAN <u>NEVER</u> GO BAD. NEVER!!

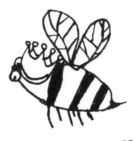

THE QUEEN BEE WAS CALLED "THE KING" UNTIL THE LATE 17th CENTURY, WHEN SCIENTISTS HAD TO ADMIT THAT SHE WAS IN FACT A FEMALE!

TIGERS
HAVE THE SAME PATTERN
ON THEIR SKIN
AS ON THEIR FUR!

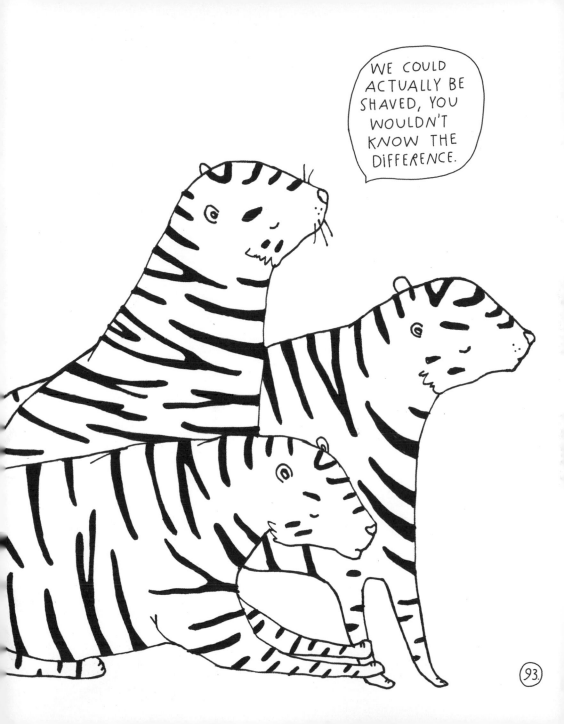

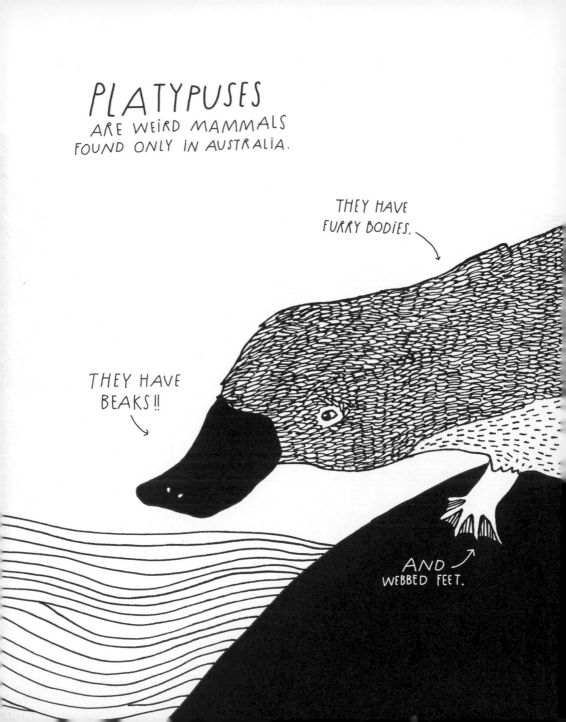

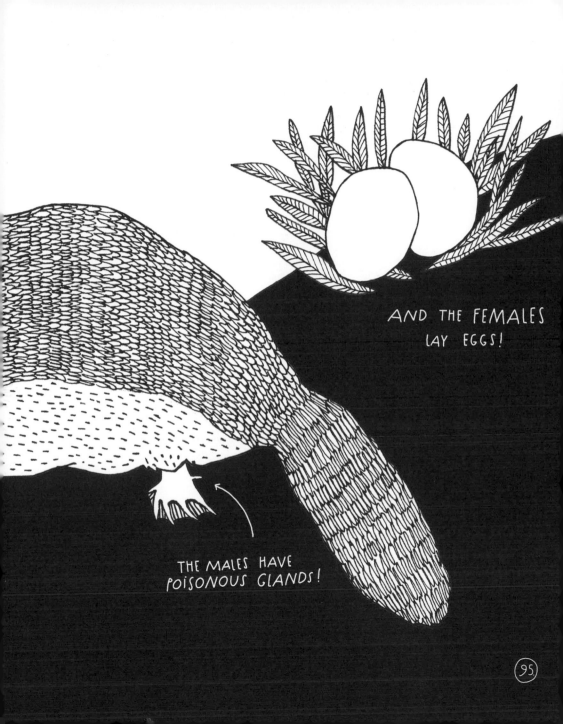

AND THE FEMALES
LAY EGGS!

THE MALES HAVE
POISONOUS GLANDS!

COWS
CAN SLEEP STANDING UP,
BUT THEY CAN ONLY DREAM
WHEN LYING DOWN!

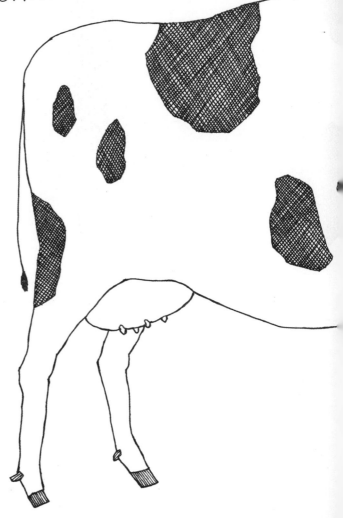

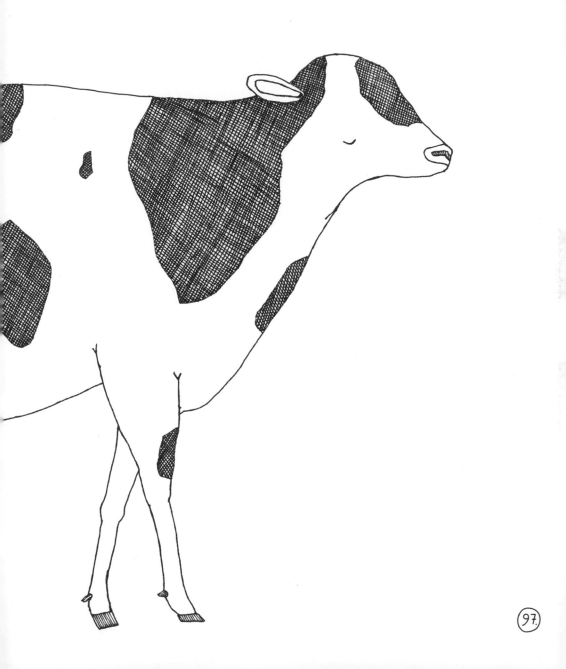

97.

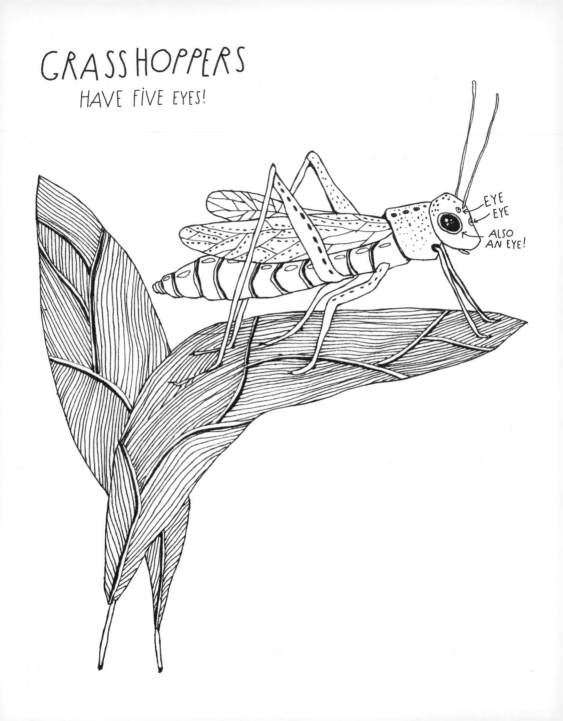

AND THEY CAN JUMP
TWENTY TIMES
THE LENGTH
OF THEIR BODIES.

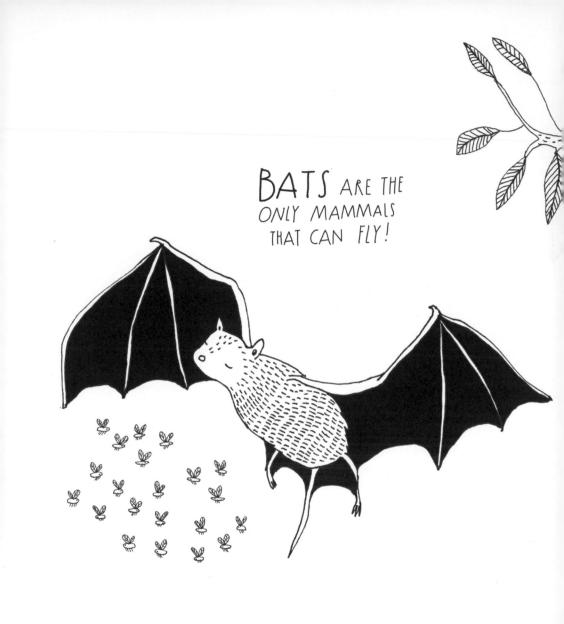

BATS ARE THE ONLY MAMMALS THAT CAN FLY!

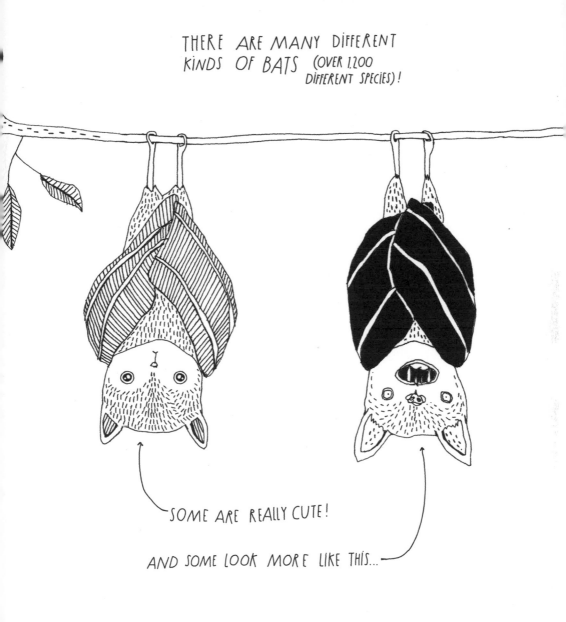

THERE ARE MANY DIFFERENT
KINDS OF BATS (OVER 1,200
DIFFERENT SPECIES)!

SOME ARE REALLY CUTE!

AND SOME LOOK MORE LIKE THIS...

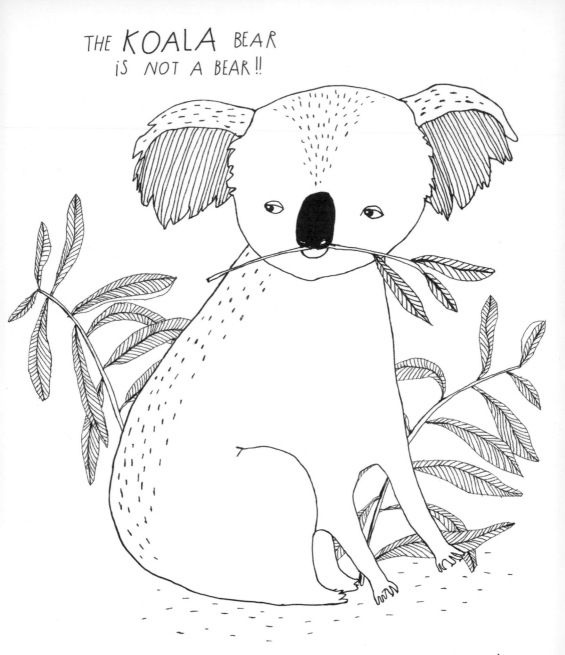

THE KOALA BEAR
iS NOT A BEAR!!

(THEY ARE MORE CLOSELY RELATED TO KANGAROOS.)

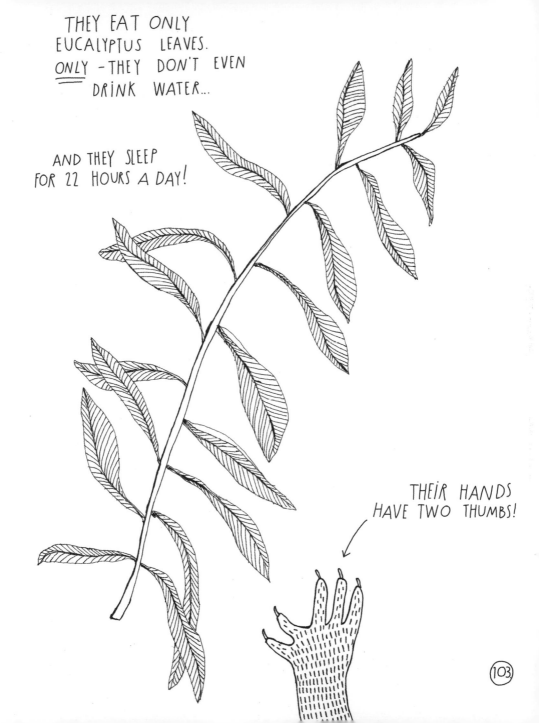

THEY EAT ONLY
EUCALYPTUS LEAVES.
ONLY - THEY DON'T EVEN
DRINK WATER...

AND THEY SLEEP
FOR 22 HOURS A DAY!

THEIR HANDS
HAVE TWO THUMBS!

FLAMINGOS

CAN ONLY EAT WITH
THEIR HEADS
UPSIDE DOWN.

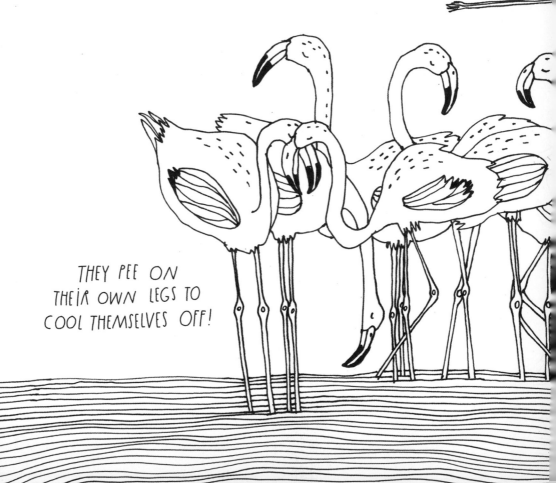

THEY PEE ON
THEIR OWN LEGS TO
COOL THEMSELVES OFF!

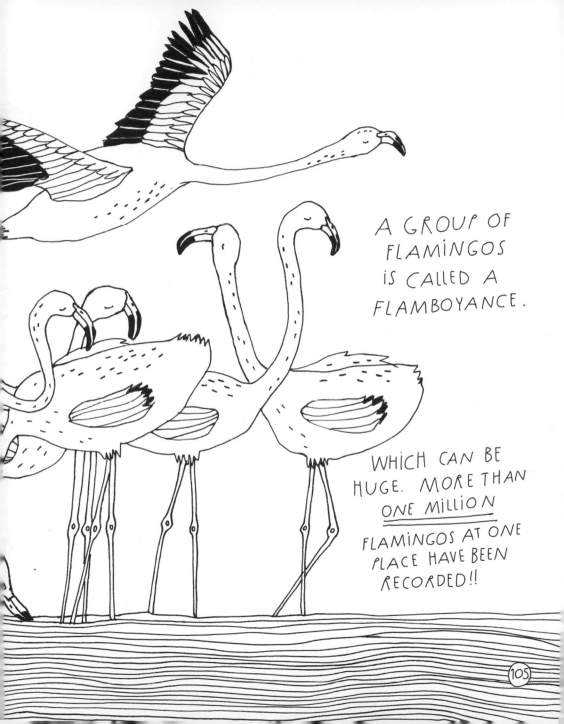

A GROUP OF FLAMINGOS IS CALLED A FLAMBOYANCE.

WHICH CAN BE HUGE. MORE THAN ONE MILLION FLAMINGOS AT ONE PLACE HAVE BEEN RECORDED!!

AN ADULT
RHINO
CAN PRODUCE OVER
45 POUNDS (20 KILOS)
OF DUNG IN A DAY!

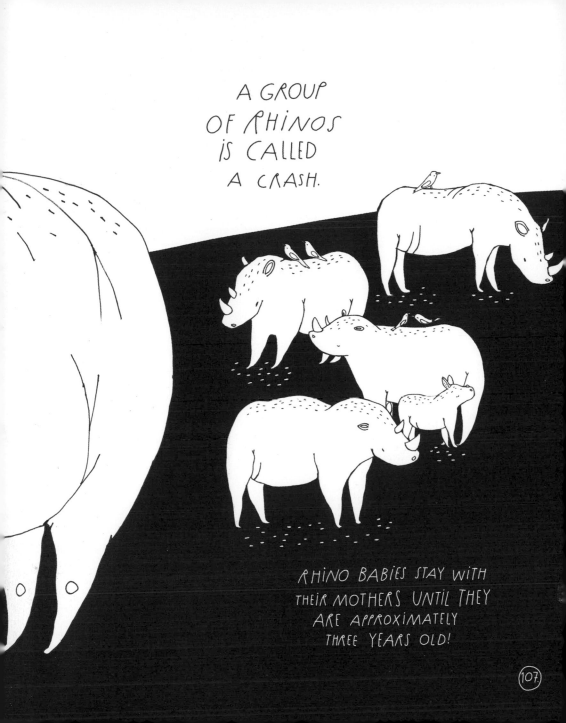

A GROUP
OF RHINOS
IS CALLED
A CRASH.

RHINO BABIES STAY WITH
THEIR MOTHERS UNTIL THEY
ARE APPROXIMATELY
THREE YEARS OLD!

107.

SHARKS

CONSTANTLY GROW
NEW TEETH.
(UP TO 30,000 IN A LIFETIME!!!)

SHARK MOMS
LOSE THEIR APPETITE
BEFORE GIVING BIRTH
SO THEY WON'T
BE TEMPTED TO
EAT THEIR OWN BABIES!

SLOTHS ARE SO
SLOW THAT THEY GROW
GREEN ALGAE ON THEIR FUR.

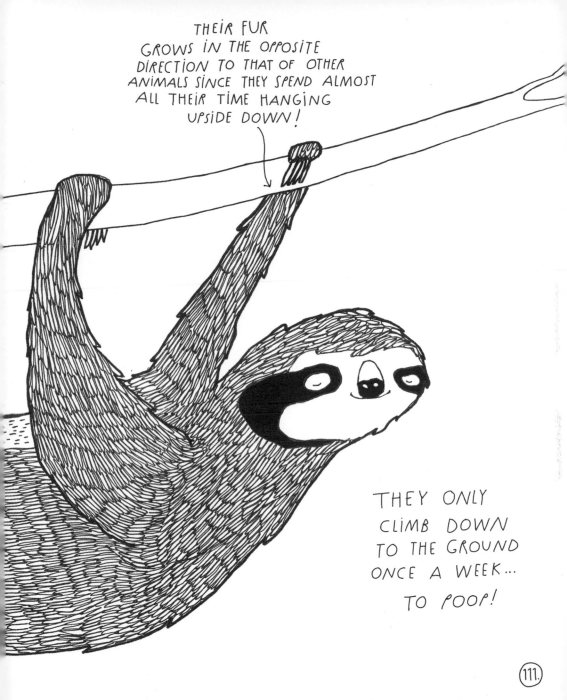

A GROUP OF
COCKROACHES
IS CALLED AN INTRUSION!

COCKROACHES
CAN LIVE FOR DAYS
AFTER THEIR HEADS
HAVE BEEN CUT OFF!

COCKROACHES CAN EAT
ALMOST ANYTHING,
BUT THEY DON'T LIKE
CUCUMBERS...

THE FUR OF
POLAR BEARS
is NOT ACTUALLY
WHITE; IT'S CLEAR.
BUT THEIR SKIN IS BLACK!

THIS IS REALLY CLEVER,
BECAUSE THEIR BLACK SKIN ABSORBS HEAT
FROM THE SUN, AND THEIR CLEAR FUR
REFLECTS THE SNOW, HELPING THEM BLEND IN
WITH THEIR ENVIRONMENT!

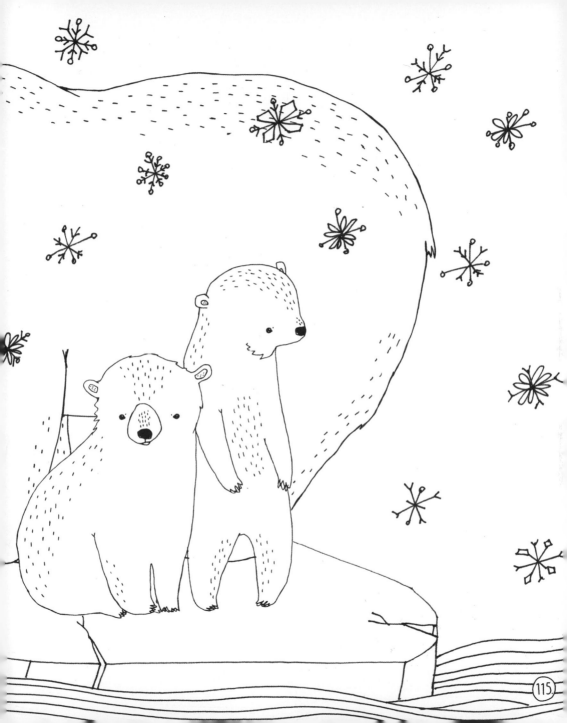

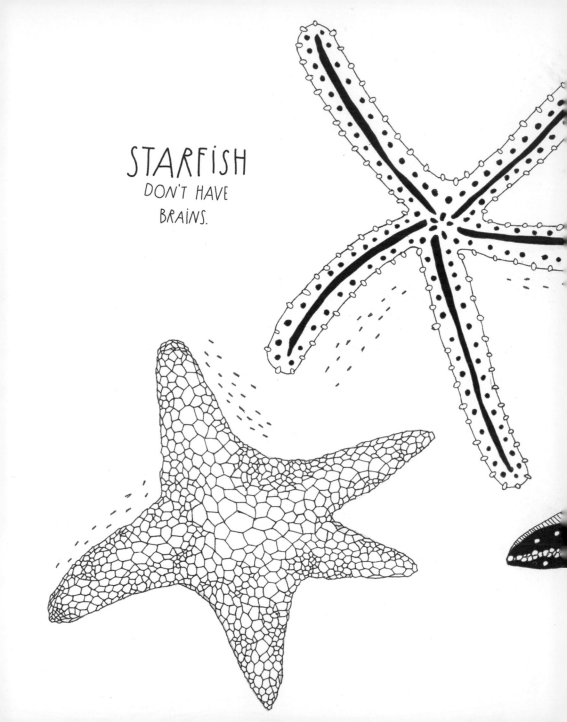

STARFISH
DON'T HAVE
BRAINS.

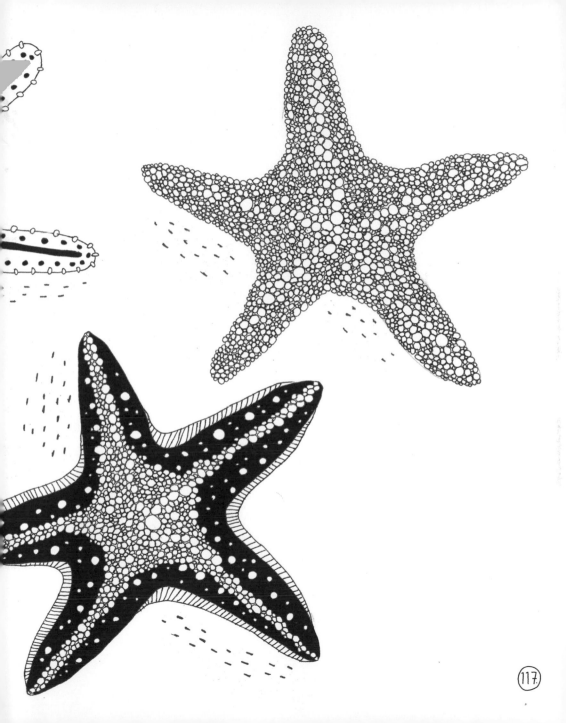

MAJA SÄFSTRÖM

MAJA IS A STOCKHOLM BASED ARCHITECT & ILLUSTRATOR WHO HAS GAINED INTERNATIONAL RECOGNITION FOR HER QUIRKY ANIMAL DRAWINGS.

FOR MORE OF HER WORKS, VISIT:

WWW.MAJASBOK.SE

119

PUBLISHED IN THE UNITED STATES BY TEN SPEED PRESS, AN IMPRINT OF THE CROWN PUBLISHING GROUP, A DIVISION OF PENGUIN RANDOM HOUSE LLC, NEW YORK.

WWW.CROWNPUBLISHING.COM
WWW.TENSPEED.COM

TEN SPEED PRESS AND THE TEN SPEED PRESS COLOPHON ARE REGISTERED TRADEMARKS OF PENGUIN RANDOM HOUSE LLC.

LIBRARY OF CONGRESS CATALOGING-IN-PUBLICATION DATA IS ON FILE WITH THE PUBLISHER.
HARDCOVER ISBN: 978-1-60774-832-8
eBOOK ISBN: 978-1-60774-833-5

PRINTED IN CHINA

DESIGN BY EMMA CAMPION

10 9 8 7 6 5 4 3 2 1

FIRST EDITION